'In contemporary English letters John Berger seems to me peerless. Not since D.H. Lawrence has there been a writer who offers such attentiveness to the sensual world with responsiveness to the imperatives of conscience.' – Susan Sontag

'In his ceaselessly inventive work, Selçuk often uses parts of the body in ways that are dry-eyed and characteristically Turkish – not Protestant, nor Mediterranean – as if the comedy of the human condition were there in the human body, in the melancholy of anatomy.' – John Berger

Storyteller, essayist, screenwriter, dramatist and critic, John Berger is one of the most internationally influential writers of the last fifty years. His many books include *Ways of Seeing* (1972), the Booker prizewinning novel *G* (1972), *Here is Where We Meet* (2005) and, most recently, *From A to X* (2008). He lives in a small village community in France.

Selçuk Demirel was born in Artvin, Turkey, in 1954. He trained as an architect and moved to Paris in 1978, where he still lives. His illustrations and books have appeared in many prominent European and American publications. Demirel's work ranges from book illustrations, magazine covers, albums of drawings to children's books, and from postcards to posters.

John Berger

—

CATARACT

—

With drawings by Selçuk Demirel

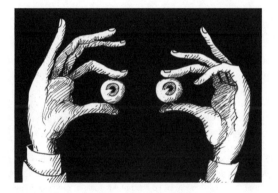

Some Notes after having a cataract removed

 Notting Hill Editions

Published in 2011
by Notting Hill Editions Ltd
Newcombe House, 45 Notting Hill Gate
London W11 3LQ

Designed & typeset
by Flok, Berlin, Germany

Printed and bound
by Memminger MedienCentrum, Memmingen, Germany

A CIP record for this book
is available from the British Library
ISBN 978-1-907-90332-8

www.nottinghilleditions.com

This book is dedicated to the department of Professor Baudouin at the Quinze-Vingts Eye Hospital in Paris and to Dr. Dupont-Monod.

Cataract from Greek *kataraktes*, meaning
waterfall or portcullis, an obstruction that
descends from above. Portcullis in front
of the left eye removed. On the right eye
the cataract remains.

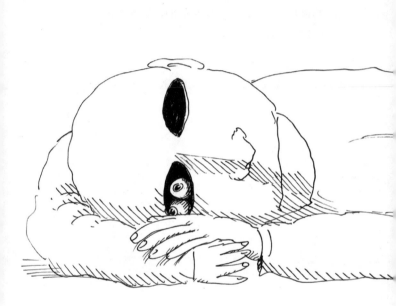

I play, looking at an object and then closing first my left eye, then the right. The two visions are distinctly different. Define the difference(s).

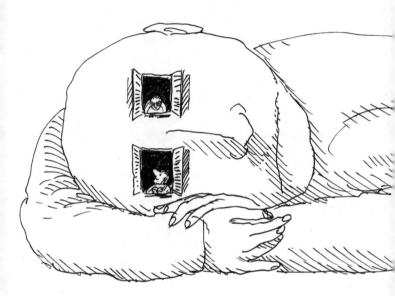

With the right eye alone, everything looks worn, with the left eye alone, everything looks new. This is not to say the object being looked at changes its evident age; its own signs of relative age or freshness remain the same. What changes is the light falling on the object and being reflected off it. It is the light that renews or – when diminished – makes old.

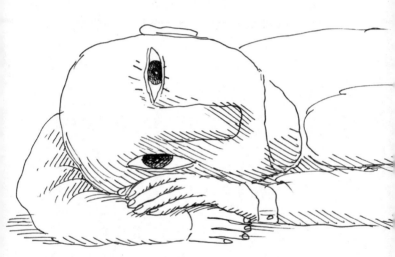

Light which makes life and the
visible possible. Perhaps here we
touch the metaphysics of light
(to travel at the speed of light means
leaving behind the temporal dimension.)
On whatever it falls light bestows
a quality of firstness, rendering it
pristine.

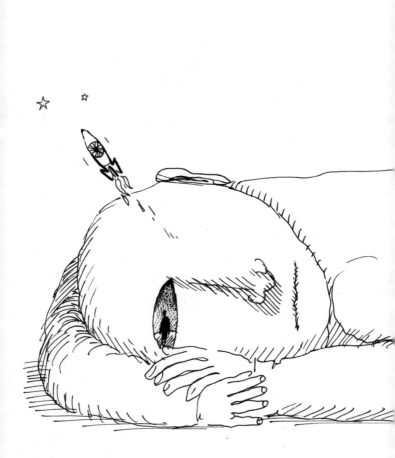

although in reality it may be a mountain
or a sea that is x million years old.
Light exists as a continuous everlasting
beginning. Darkness, by contrast, is not,
as often assumed, a finality but a prelude.
This is what my left eye, which can barely
distinguish contours yet, tells me.

The colour which has come back to a degree that I did not foresee is blue. (Blue and violet with their short waves are deflected by the opacity of the cataract.)
Not only the pure blues, also the blues which contribute to other colours.
The blues in certain greens, in certain purples and magentas and in certain greys.
It's as if the sky remembers its rendezvous with the other colours of the earth.

All these blues playing with the light create the shine of silver or tin. A shine that has nothing to do with the sedate glow of gold or copper. Silver is fast - see mercury. The silver shine of fish, running water, sunlight on leaves.

For my left eye the nights are now darker because of the sharper contrast with the shine of the days. Blue is also the colour of depth and distance.

Another difference between the vision
of the two eyes concerns distance. The
portcullis closes in. With my left eye
I can step outside, and distance increases
in two ways. I see further and,
simultaneously, any measure of distance
elongates itself: a kilometre becomes
longer as does a centimetre. I become
more aware of the air, the space, between
things, because that space is full of light
like a tumbler can be full of water.
With cataracts, wherever you are, you
are in a certain sense indoors.

As a result of my increased perception of space, my sense of the lateral – of what is happening from left to right, of what is parallel to the horizon – is increased. I am more aware of what is passing before me, as distinct from what is addressed to me. Just as distance becomes longer, largeness becomes larger.

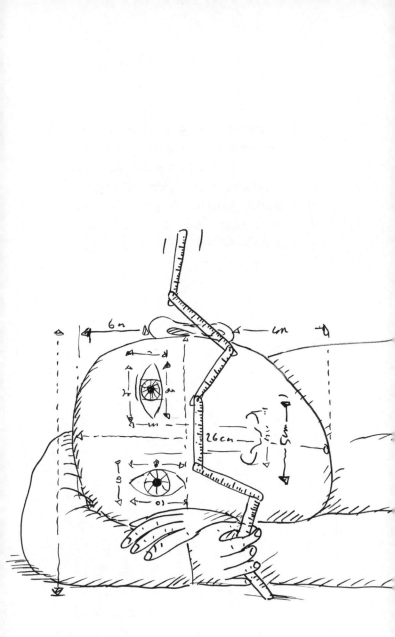

Each pair of eyes inevitably has to carry its own horizon. But this extended sense of largeness and of the lateral encourages you to imagine (as happens in childhood) a multitude of alternative horizons. The portcullis came down from above. The horizons extend in every direction.

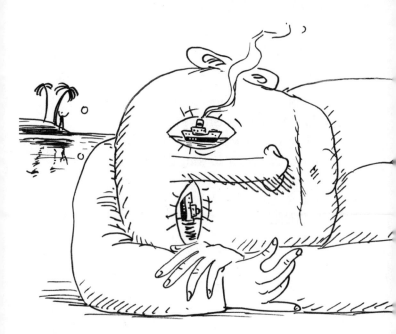

Behind my right eye hangs a burlap cloth; behind my left eye there's a mirror. I don't of course see either burlap or mirror. What I'm looking at, however, dramatically reflects their difference. Before the burlap the visible remains indifferent; before the mirror it begins to play.

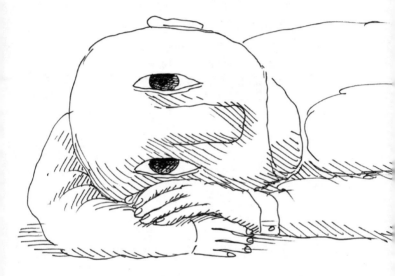

May 30th. Unusually blue sky, by any
standards, over Paris. I look up at a
fir tree and I have the impression that
the little fractal fragments of sky,
which I see between the masses of
pine needles, are the tree's blue flowers,
the colour of delphiniums.

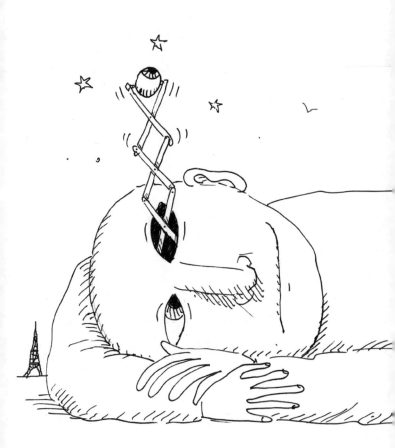

The quicksilver of the light now becomes opalescent and pearl-like. This in no way diminishes, however, the quality of firstness which the light bestows. As though light and what is lit arrive at the selfsame instant. (Is this not the secret of visibility?)

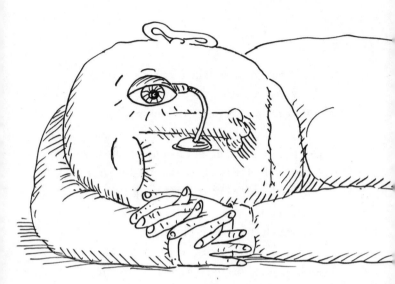

31

Tomorrow it will be three weeks after the operation. If I try to sum up the transformed experience of looking, I'd say it's like suddenly finding oneself in a scene painted by Vermeer. For example: *The Kitchen Maid* (Rijksmuseum, Amsterdam). You are looking at the objects and the bread on the table where there is the bowl, into which the maid is pouring milk from a jug, and the surface of everything you are looking at is covered with a dew of light …

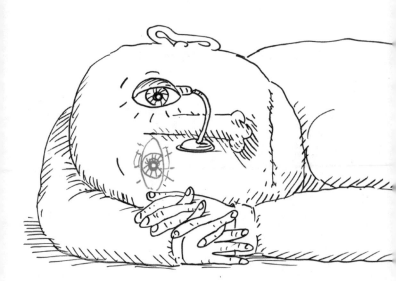

Early morning drops of light.

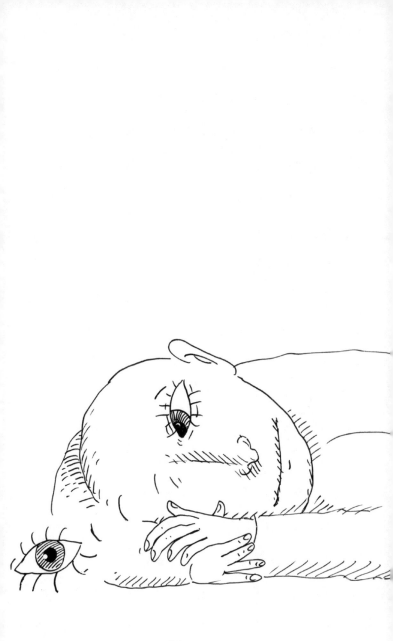

More notes after the operation on my right eye (26th March 2010), whose cataract was more rigid and opaque.

This time the onrush of light is less specific and more generalised. It's not so much that things appear better lit, but, rather that I'm acutely aware of how everything is surrounded by light. The element of air has become the element of light. Just as fish live and swim in water: we live and move through light.

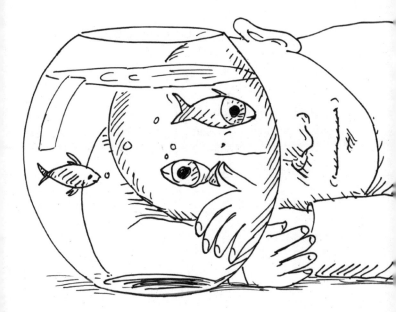

The newly found, ubiquitous light seems quiet and silent; it is shadows and darkness that are noisy.

The light places a hand on your back. You don't turn round because from a long, long time ago, you recognise its touch. It's what you first saw and never gave a name to.

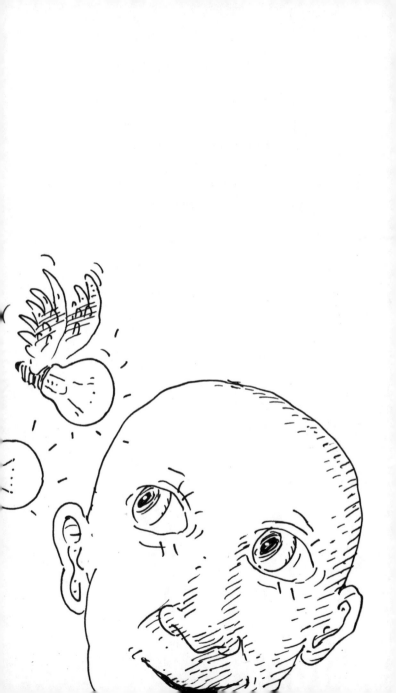

The removal of cataracts is comparable with the removal of a particular form of forgetfulness. Your eyes begin to re-remember first times. And it is in this sense that what they experience after the intervention resembles a kind of visual renaissance.

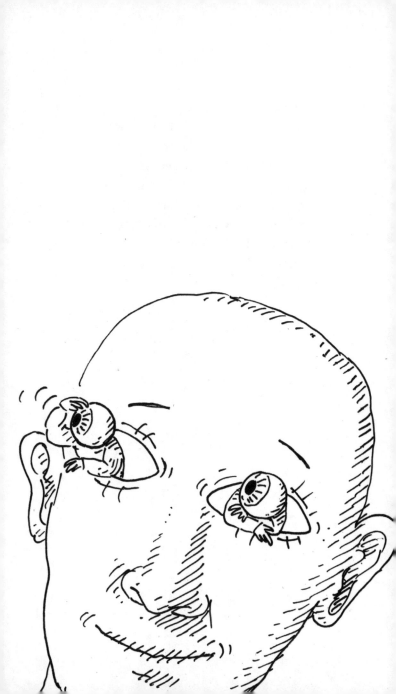

The white paper on which I'm writing today (two days after the operation) is whiter than anything I've become used to seeing. I return to my mother's kitchen in my childhood: there were comparable whites on the table, in the sink, on the shelves. And those whites of paper and porcelain and enamel contained a promise which this white paper today recalls.

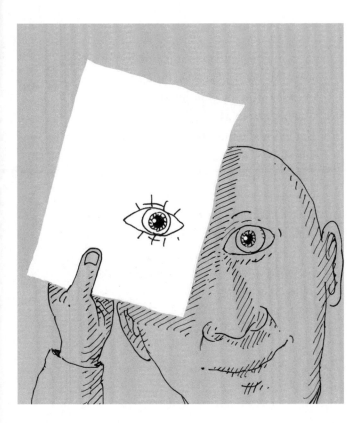

Let's be clear about the implications of
what I'm saying. Clearly, during many
decades after my childhood, I saw sheets
of white paper as white as this one.
But gradually the whiteness dimmed
without my taking account of it.
Consequently, what I called white paper
changed, grew dimmer. And this afternoon
what's happening is not that I realise this
with my intelligence, but that the whiteness
of the paper rushes towards my eyes,
and my eyes embrace the whiteness like
a long lost friend.

I'm writing on the paper with black ink.
And blacks (as distinct from dark greys,
dark blues or greens or browns) have
acquired more weight, are heavier.
Other colours flare or recede or penetrate
but blacks look as though they have
been deposited. Laid on top of. And
this connects with their weight. The black
of a natural substance - such as ebony
or obsidian or chromite - is never pure
black; other colours hide within it.
The laid-on blacks are all man-made.

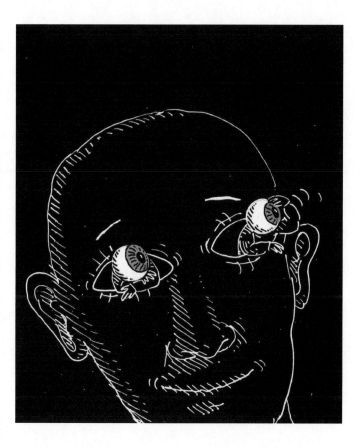

Before the operation, I made a coloured drawing of a flower - a blue pansy. I did so with the idea of making another drawing of the same flower after the operation.

Neither drawing is a copy. Both of course are interpretations of what I saw. They didn't come direct from the retinas of my eyes. Yet the difference between them is, I reckon, similar to the difference between what I perceived before and after the removal of the cataract.

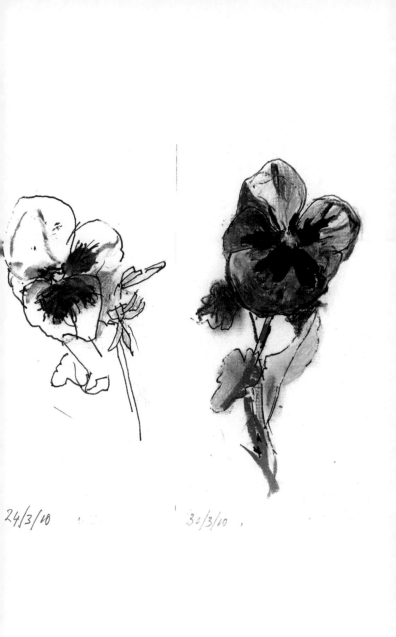

24/3/10

30/3/10

When I compare them now it is as if in the first drawing I was faithfully noting down a sequence of musical notes without being able to hear the vibrations of their physical sounds. In the second drawing the vibrations of those notes were there before my eyes.

The structure and form of the flower is unchanged, as is the botanical logic of its colouring. What has changed is the intimacy of its colouring. Its colours have become naked before my eyes.

After this operation, unlike the first, the treated eye began, an hour or two after the intervention, to hurt and this continued for about a day. With mild painkillers it was quite tolerable. The passage through this small pain was inseparable from my journey towards a newly visible world. I emerged from the pain at the threshold of a new visibility.

A surgical intervention to remove cataracts gives back to the eyes much of their lost talent. Talent, however, invariably implies a certain amount of effort and endurance as well as grace and benefit. And so the new visibility represented for me not only a gift but an achievement. Principally the achievement of the doctors and nurses who carried out the intervention, and also, to some small degree, the achievement of my own body.

The pain made me aware of this.

When you open a dictionary and consult it, you refind, or discover for the first time, the precision of a word. Not only the precision of what it denotes, but also the word's precise place in the diversity of the language.

With both cataracts removed, what I see with my eyes is now like a dictionary which I can consult about the precision of things. The thing in itself, and also its place amongst other things.

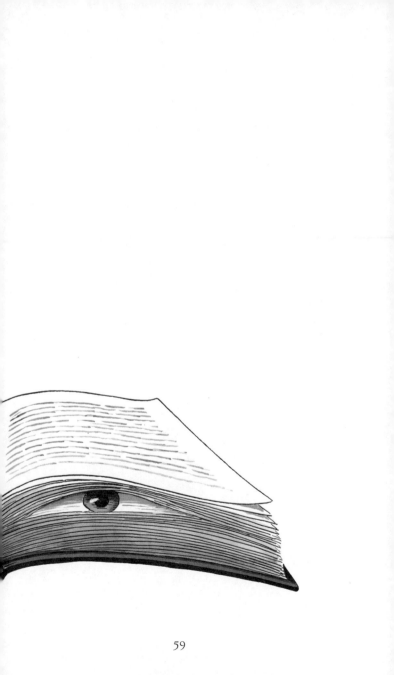

I'm far more aware of comparative scale:
the small becomes smaller, the large
larger, the immense more immense.
And the same is true, not only of things,
but of spaces. The small becomes more
intimate, the large more extensive. And
this is because details - the exact grey of
the sky in a certain direction, the way
a knuckle creases when a hand is relaxed,
the slope of a green field on the far side
of a house - such details reassume a
forgotten significance.

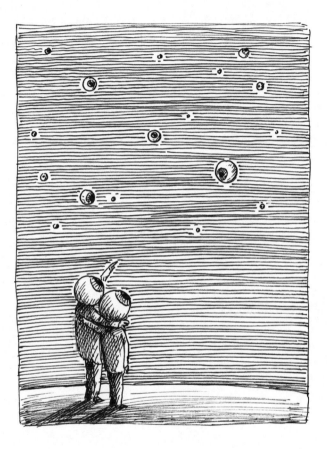

The unstartling heterogeneousness of
the existent has marvellously returned.
And the two eyes, portcullises removed,
again and again register surprise.

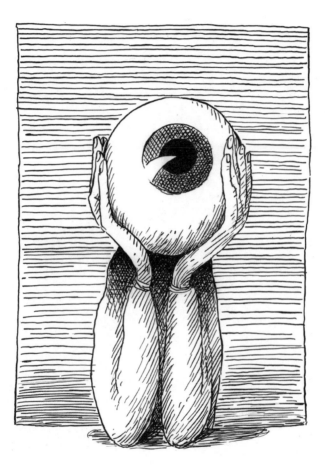

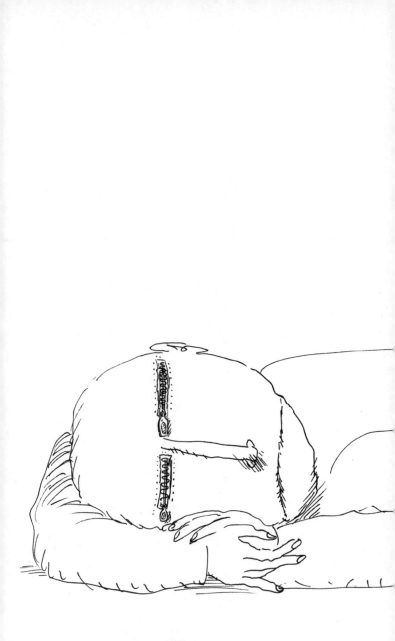

Smoke by John Berger
With drawings by Selçuk Demirel

*'Just time for a smoke
and a story…'*

The great John Berger, art critic, novelist and long-time smoker,
joins forces again with Turkish writer and illustrator
Selçuk Demirel in an unexpected pictorial essay.

*'Once upon a time, men, women and (secretly)
children smoked.'*

This charming pictorial essay reflects on the cultural implications
of smoking, and suggests, through a series of brilliantly inventive
illustrations, that society's attitude to smoke is both paradoxical
and intolerant. It portrays a world in which smokers, banished
from public places, must encounter one another as outlaws.
Meanwhile, car exhausts and factory chimneys continue to
pollute the atmosphere.

Smoke is a beautifully illustrated prose poem that lingers
in the mind.

What Time Is It? by John Berger
With drawings by Selçuk Demirel and introduced
by Maria Nadotti

Visionary thinker John Berger and Turkish artist Selçuk Demirel
came together came together for the last time to create this
precious little volume about time.

What Time Is It? is a playful meditation on the illusory nature of
time. Our perception of time assumes a uniform and ceaseless

passing of hours, but Berger suggests that time is turbulent. It expands and contracts according to the intensity of the lived moment. In this beautiful essay in pictures, Berger posits the idea that by experiencing the extraordinary, we can defy time itself.

Illustrated throughout in full colour by Selçuk Demirel in his inventive style and introduced by Berger's friend Maria Nadotti. This title completes a trilogy of illustrated books by Berger and Demirel, including *Cataract* (2011) and *Smoke* (2017).

In 1571, shortly after a near-death experience, Montaigne retired to a room in his tower where he began to write his famous essays. These 'whimsies' are intimate, revelatory and explore themes of fear and courage, mortality and personal freedom, ideas considered so dangerous that his books were banned by the Vatican for nearly two centuries. In his introduction, Tim Parks sheds new light on this enduringly popular figure.

Mourning Diary by Roland Barthes

Translated by Richard Howard, Preface by Michael Wood

The French critic Roland Barthes has guru status among literary theorists. This private diary opens the door onto his strange personal world, recording, day-by-day, the impact of bereavement as he struggled to live without the most important person in his life: his mother.

'Precise and touching memories intersect with spare and at times desperate notes on time, death, and grief.' Julian Barnes

I Remember by Joe Brainard

Introduced by Paul Auster, with an afterword by Ron Padgett

'*I Remember* is a masterpiece. One by one, the so-called important books of our time will be forgotten, but Joe Brainard's modest little gem will endure.' Paul Auster

Joe Brainard's *I Remember* is a cult classic, envied and admired by writers from Frank O'Hara to John Ashbery and Edmund White. As autobiography, Brainard's method was brilliantly simple: to set down specific memories as they rose to the surface of his consciousness, each prefaced by the refrain 'I remember'.

Introduced by Paul Auster with an Afterword by Ron Padgett. Forty-two years after its original US publication in 1970, this is the first UK edition.

Junkspace with Running Room by Rem Koolhaas and Hal Foster

Is there a future for architecture? If so, it might begin with the meditations – by turns elegant and frantic – of Rem Koolhaas and Hal Foster. In *Junkspace*, Dutch architect Rem Koolhaas itemises in delirious detail how our cities are being overwhelmed in a brilliant performance that calls to mind other critical manifestos on the corruption of the marketplace by writers such as James Joyce, Don DeLillo and David Foster Wallace. Twinned here for the first time with the compelling essay *Running Room*, a response to Koolhaas, by celebrated cultural critic Hal Foster.

Frida Kahlo and My Left Leg by Emily Rapp Black

At first sight of Frida Kahlo's painting *The Two Fridas* (1939),
Emily Rapp Black felt a connection with the artist. Like Kahlo,
who sustained lifelong injuries after a bus crash which led to the
loss of her right leg, *New York Times* bestselling writer Rapp
Black has been an amputee since the age of four.
In *Frida Kahlo and My Left Leg*, Rapp Black examines how she
began to recognise – and make sense of – aspects of her own
life, and experience, via Kahlo's extraordinary art. Drawing on
the art, letters and diaries of Frida Kahlo, Rapp Black takes the
reader on an exhilarating journey to understand the place of
disfigured bodies in our air-brushed world.

*All titles are available in the UK, and some titles are available
in the rest of the world. For more information please visit
www.nottinghilleditions.com.

A selection of our titles is distributed in the US and Canada by
New York Review Books. For more information on available
titles please visit www.nyrb.com